THE
FLASH BOOK
CHRIS GARVER
TATTOO DESIGNS TO COLOR

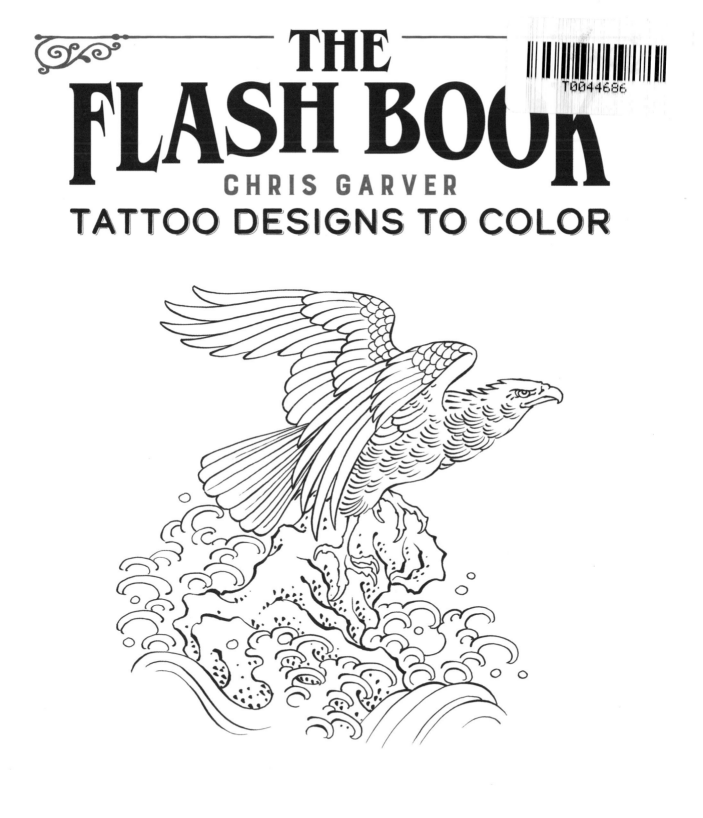

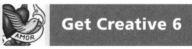 Get Creative 6

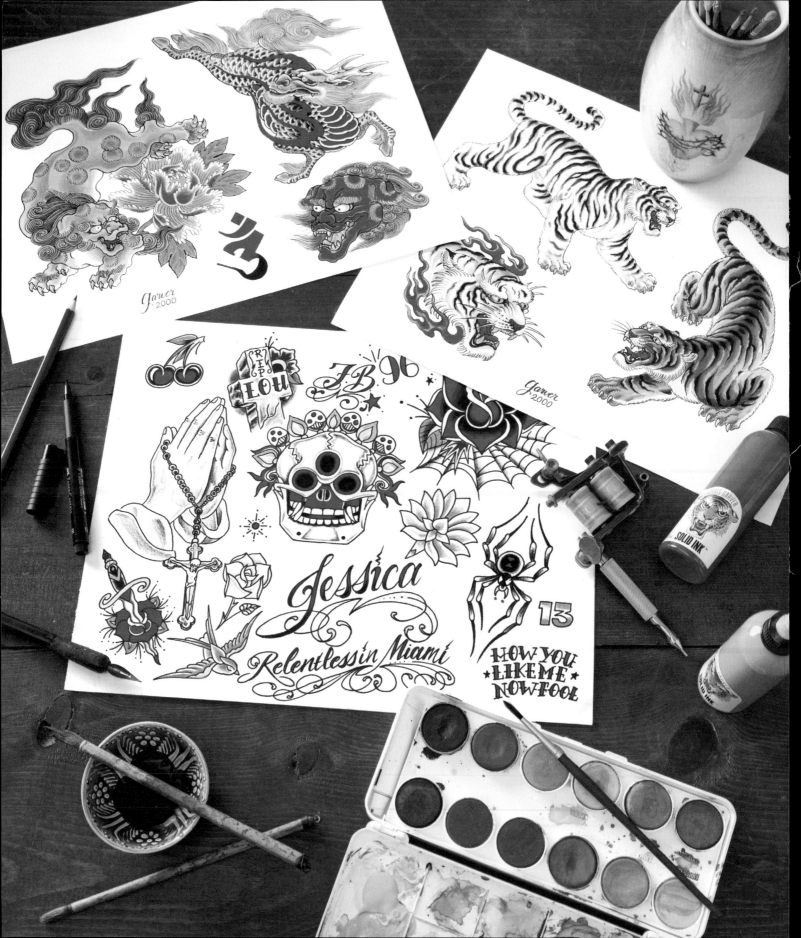

INTRODUCTION

New York City, where I've lived for a total of 25 years, is considered to be the birthplace of modern tattoos. New York is home to the first known professional tattoo shop; it's where the electric rotary tattoo machine was invented; and, shockingly, it even banned tattooing from the early 1960s through the mid-1990s. Its long and interesting history with the art form is one of the many reasons I love the city.

In the early 1900s, many tattooists, including those in New York City, began putting handfuls of small drawings on single pages that came to be known as flash sheets. Hanging these in their shops made it easier for people to spot tattoos they'd like to get. After more than 100 years, flash sheets continue to be used in tattoo shops, and many of the same images and motifs have been drawn over and over again by countless tattoo artists. These classic images have been subtly adapted to suit the time in which the tattooist worked, but even though the artwork has evolved over the years, you can still recognize its origins.

This coloring book is a celebration of flash, a tradition and useful tool among tattoo artists today. In this book, I've included some of my favorite tattoos, which are a mix of the modern and traditional combined with my own artistic style. You'll find pages with a single large image and pages with several smaller drawings paired together, just like what you'd find on actual flash pages in a tattoo shop. After coloring these pages, maybe you'll recognize some of the classic drawings when you see them on your friends, family, and others you meet.

— CHRIS GARVER

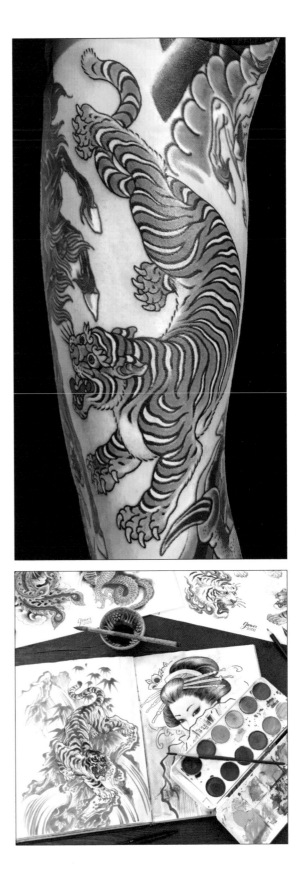

ABOUT THE AUTHOR

Well known and respected throughout the tattoo community, Chris Garver garnered mainstream attention after appearing as a regular on the reality TV show *Miami Ink*. A native of Pittsburgh, Pennsylvania, he attended the Pittsburgh Creative and Performing Arts High School and, later, New York's School of Visual Arts. An avid traveler and aficionado of all styles of tattoos, Chris has visited and worked in such locales as Japan, Singapore, England, and the Netherlands. He currently resides in New York City with his daughter, where he owns a tattoo shop called Five Points Tattoo.

Get Creative 6
is an imprint of Mixed Media Resources
19 W 21st St, Suite 601
New York, NY 10010

Editor
JACOB SEIFERT

Creative Director
IRENE LEDWITH

Senior Designer
JENNIFER MARKSON

Chief Executive Officer
CAROLINE KILMER

President
ART JOINNIDES

Chairman
JAY STEIN

Tattoo photos by Chris Garver
Still life photos by Jack Deutsch

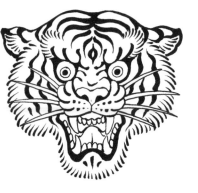

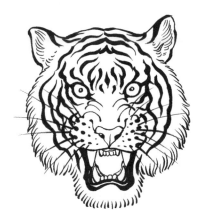

ISBN: 978-1-68462-077-7

Printed in China

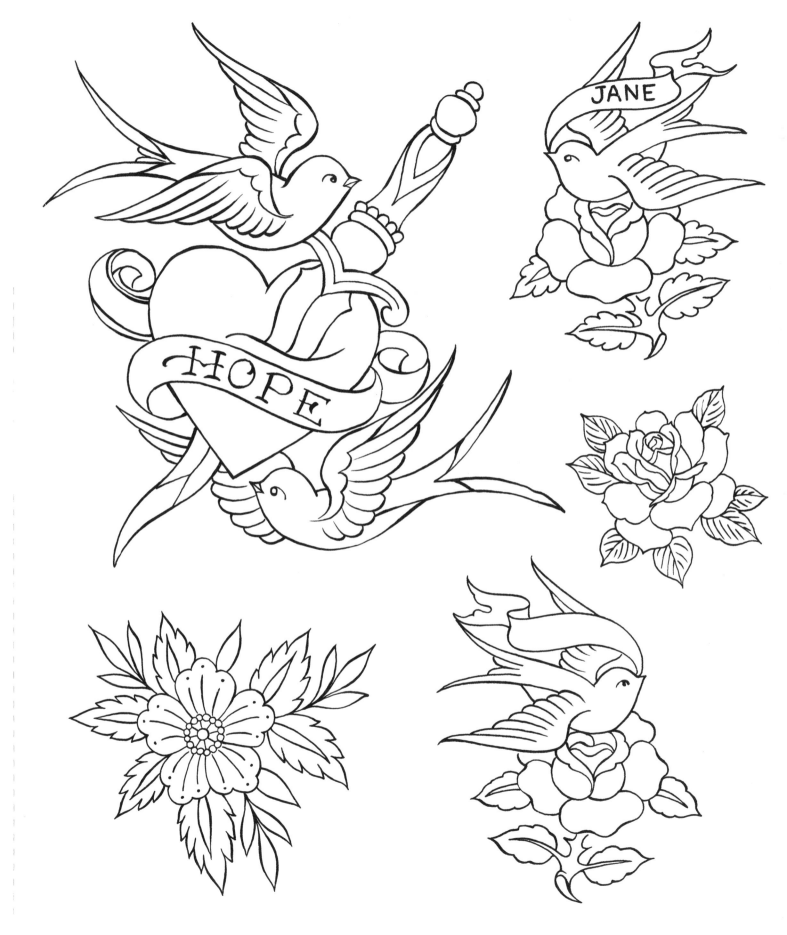

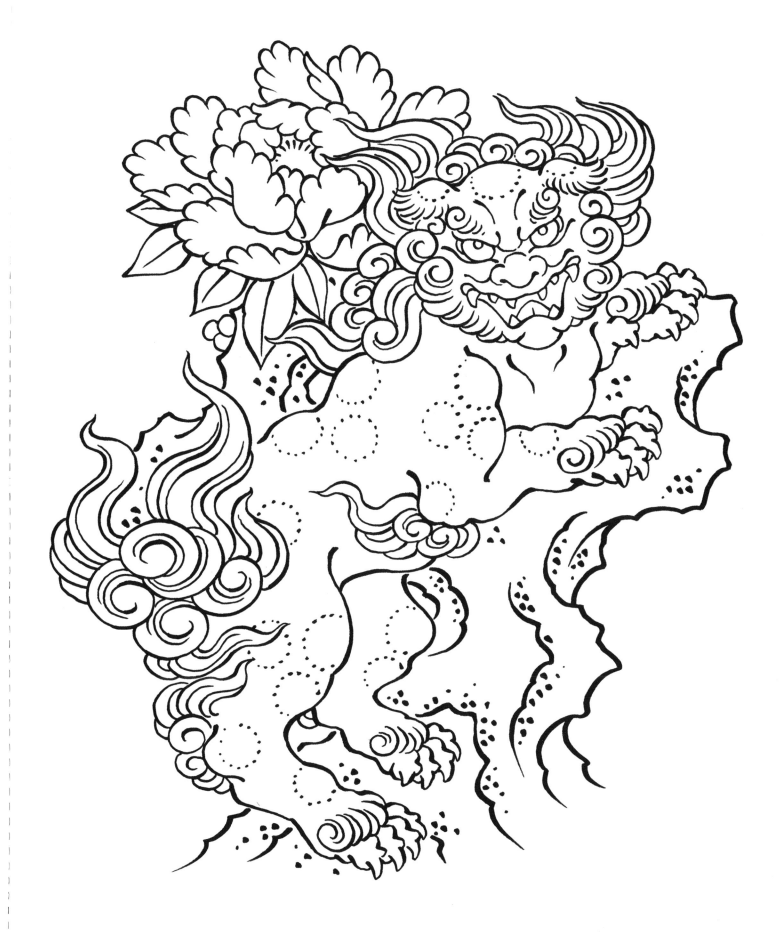

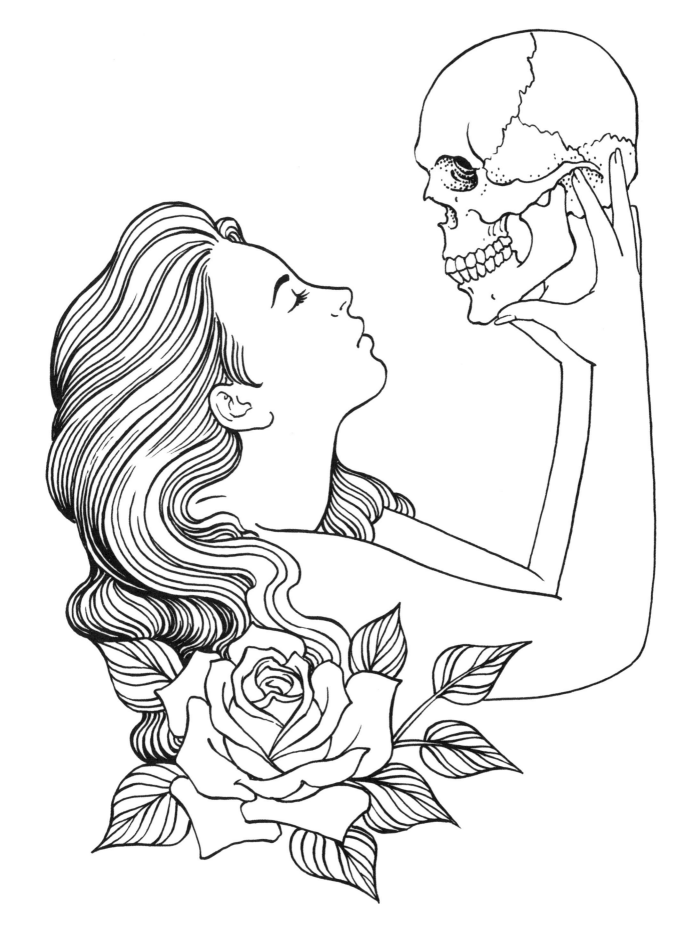

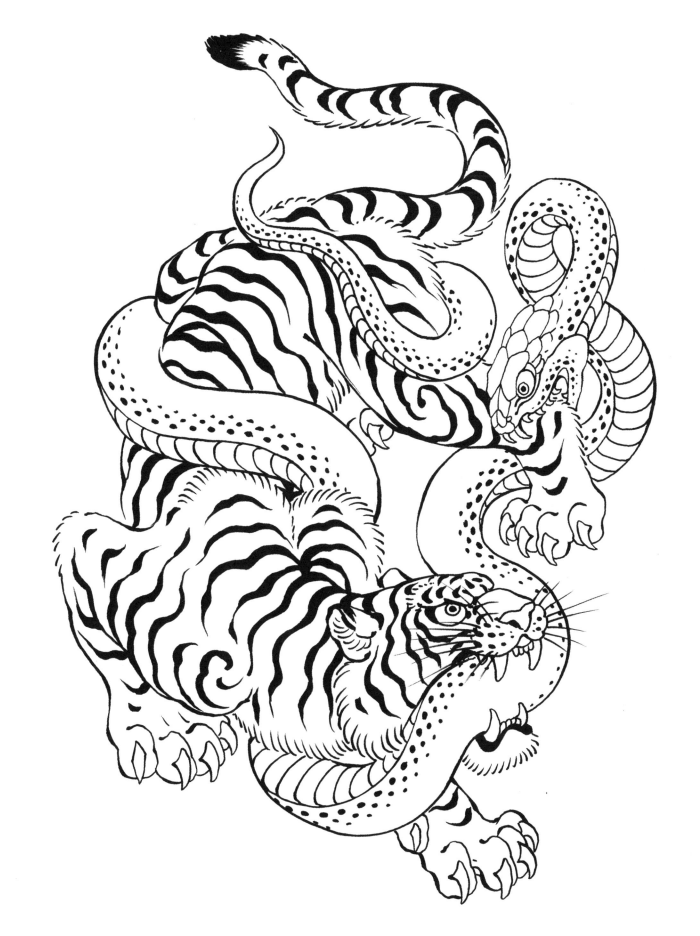

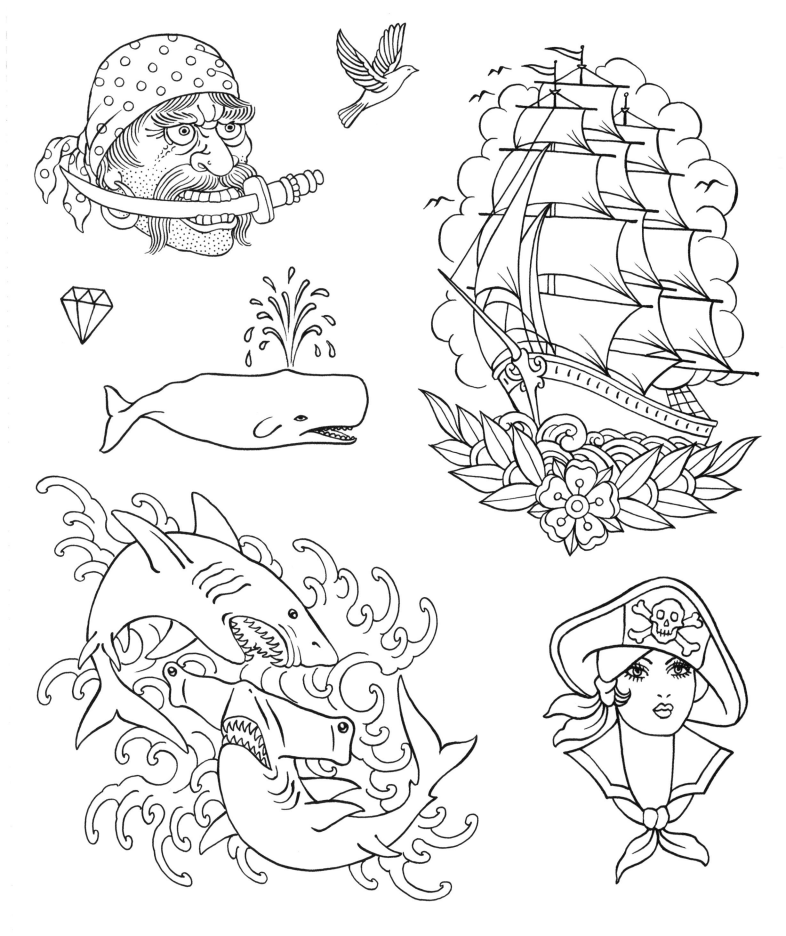

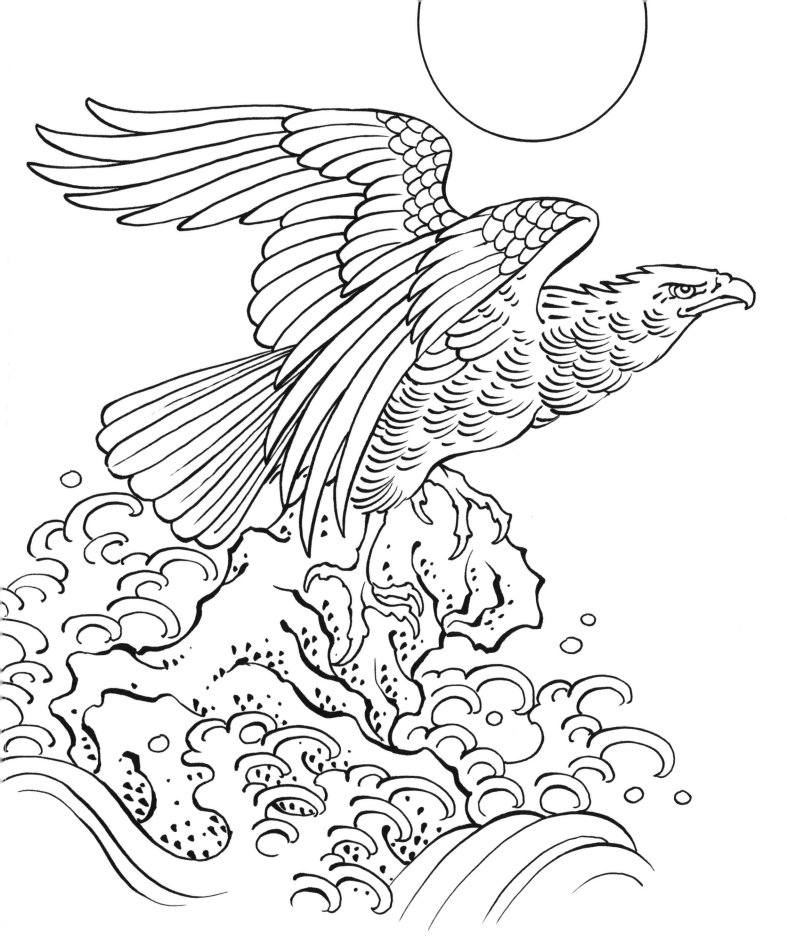

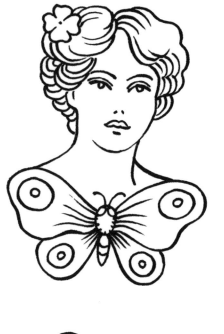

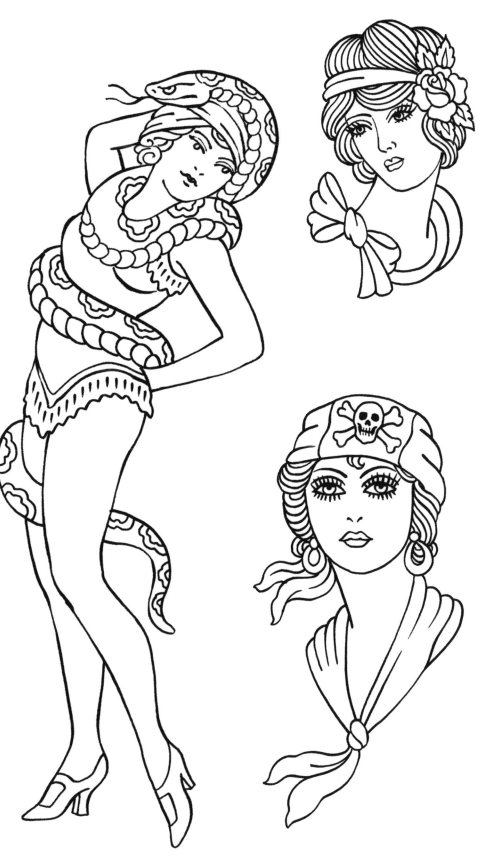

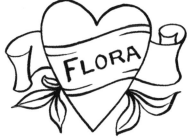

FLORA

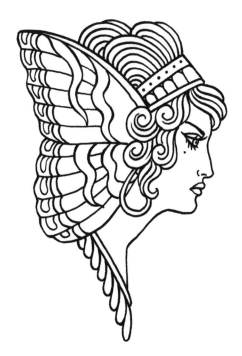

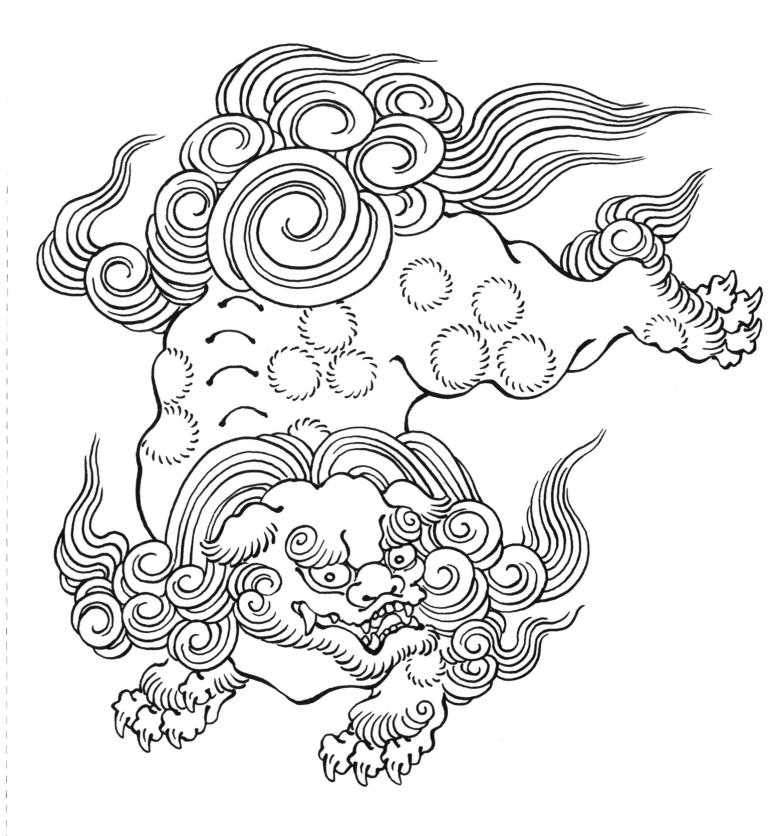

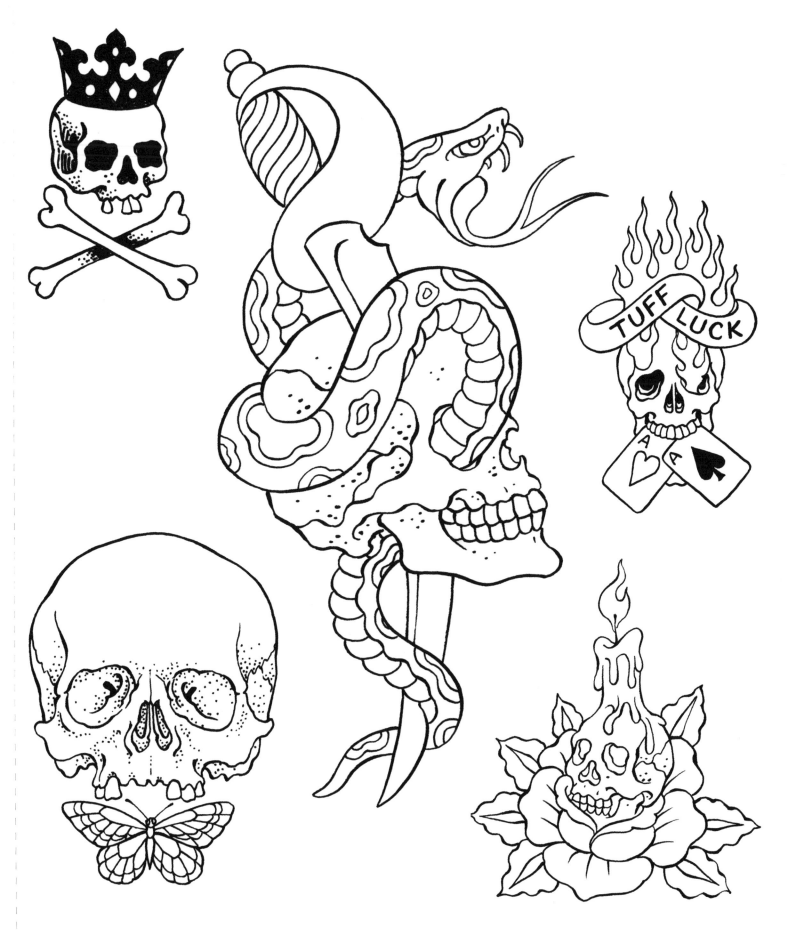

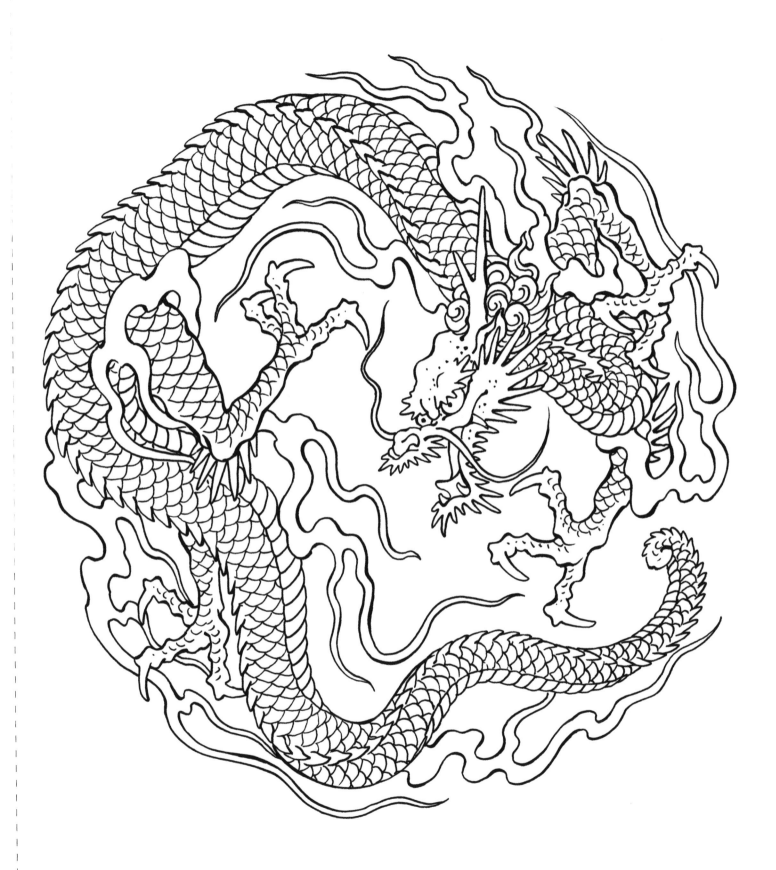

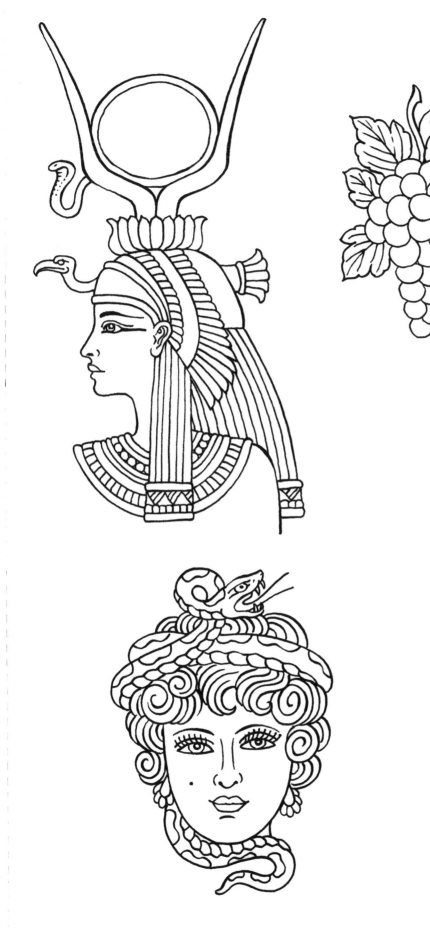
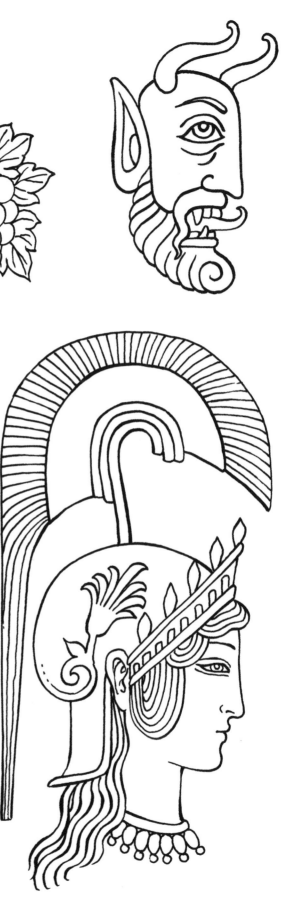

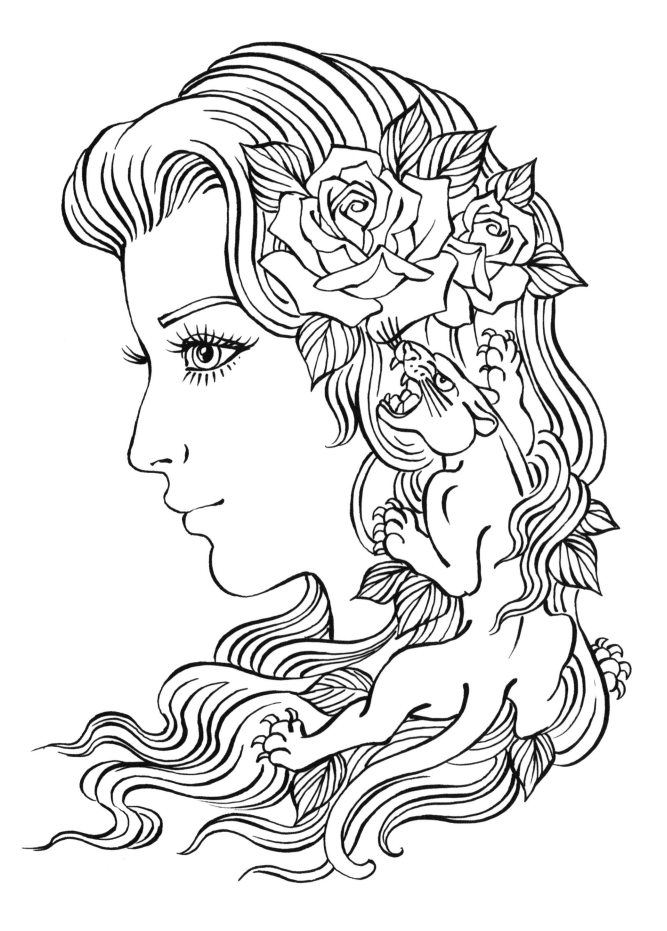

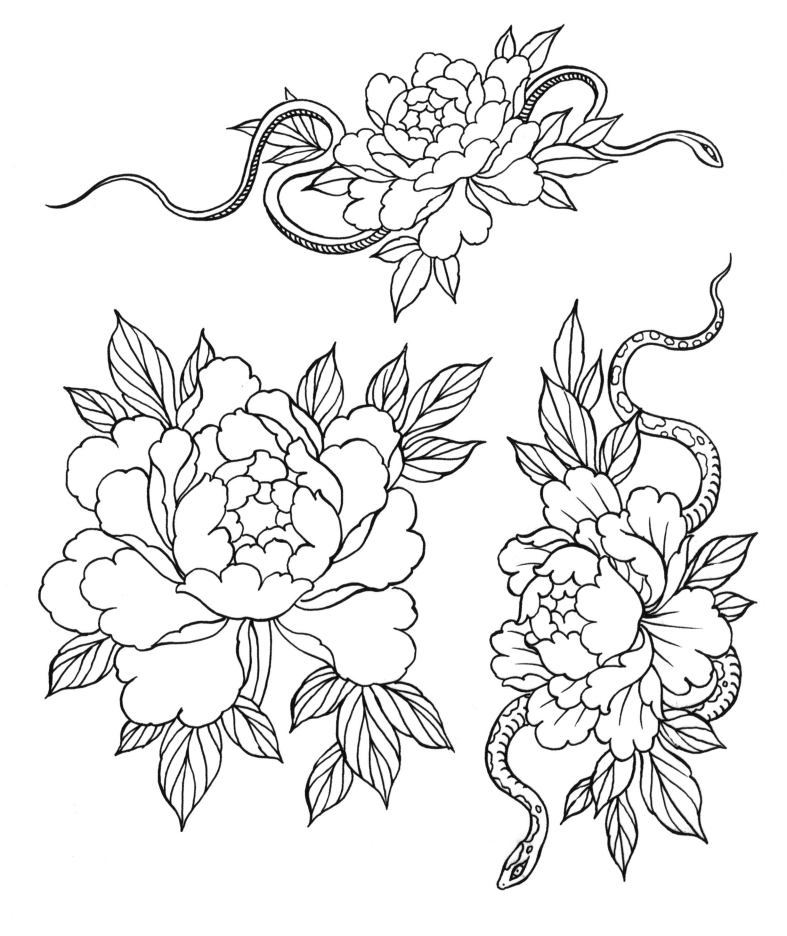

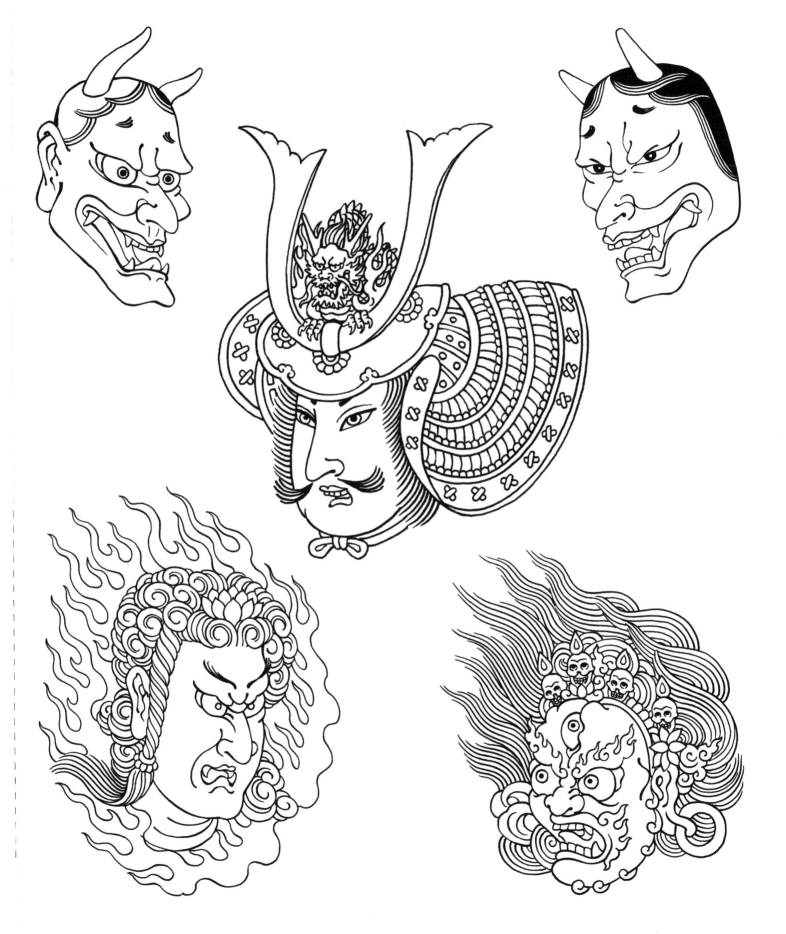

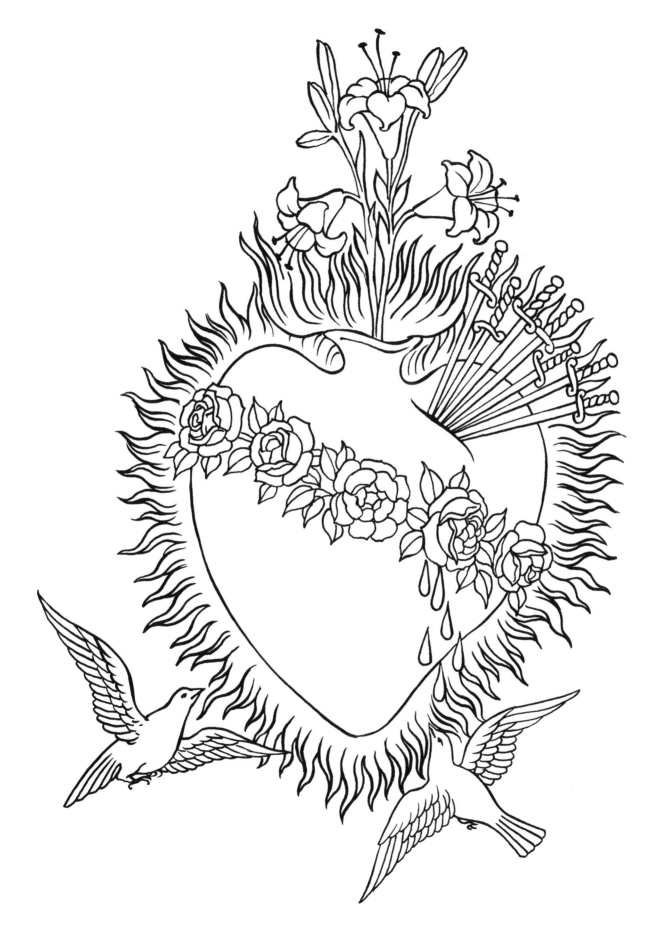

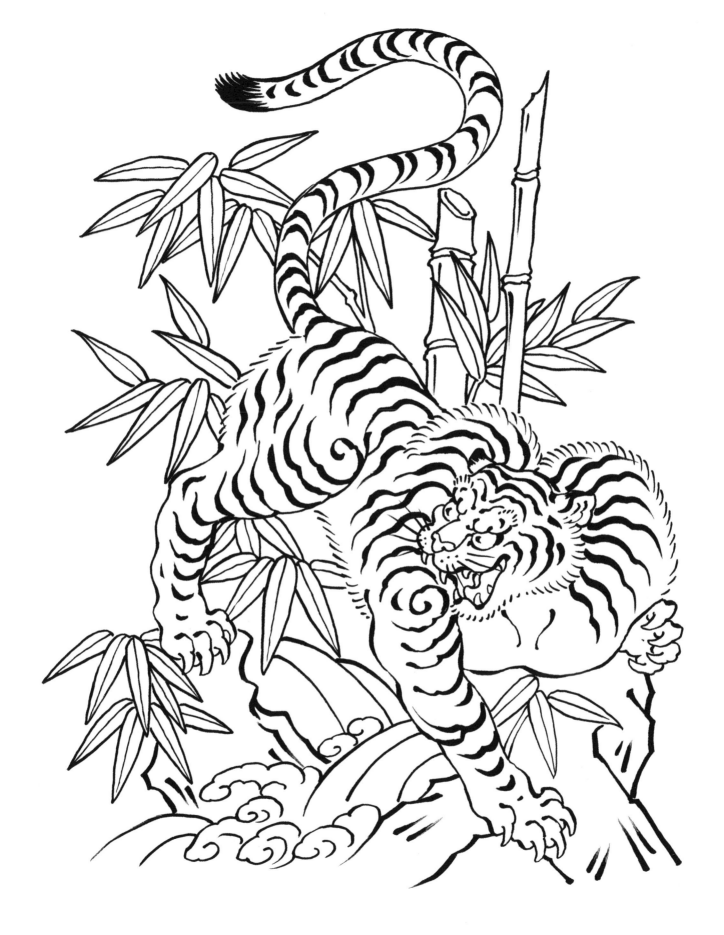

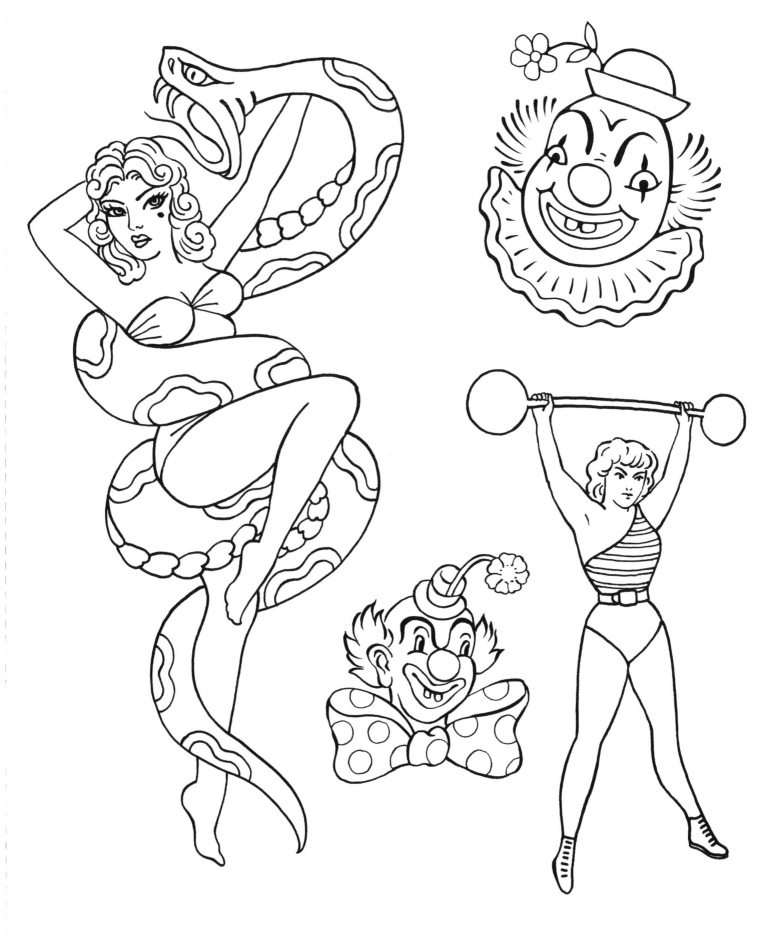

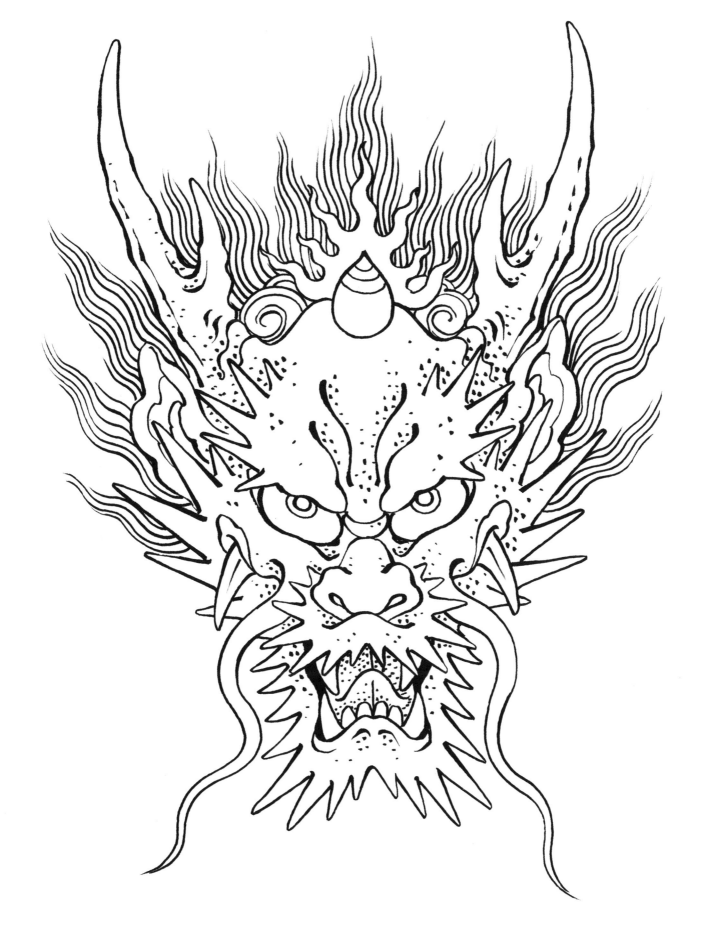

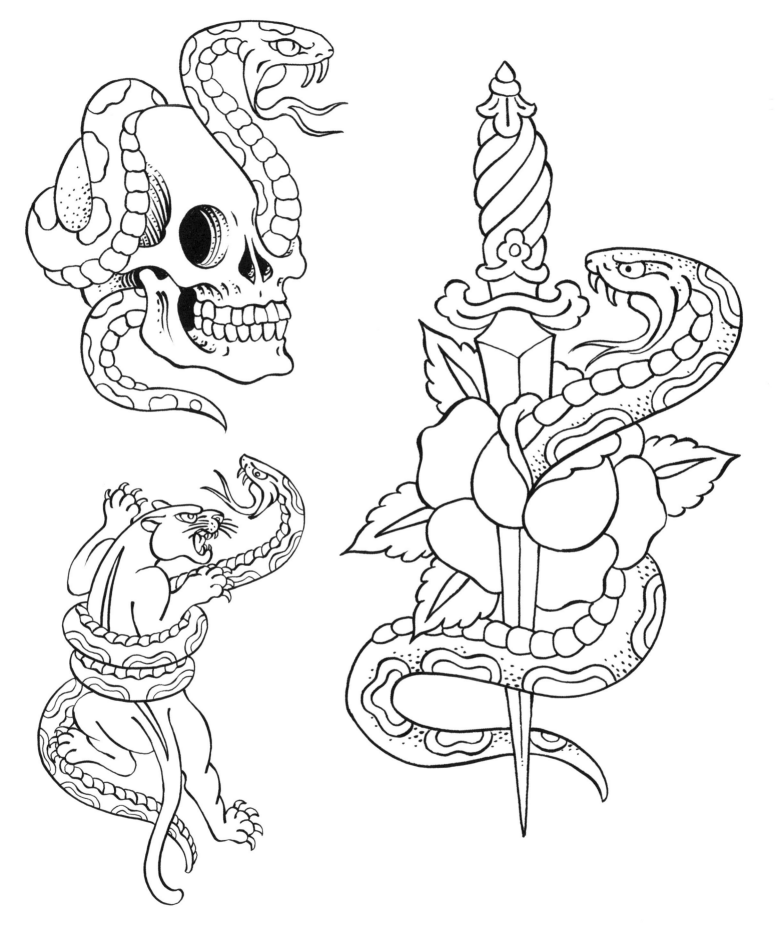

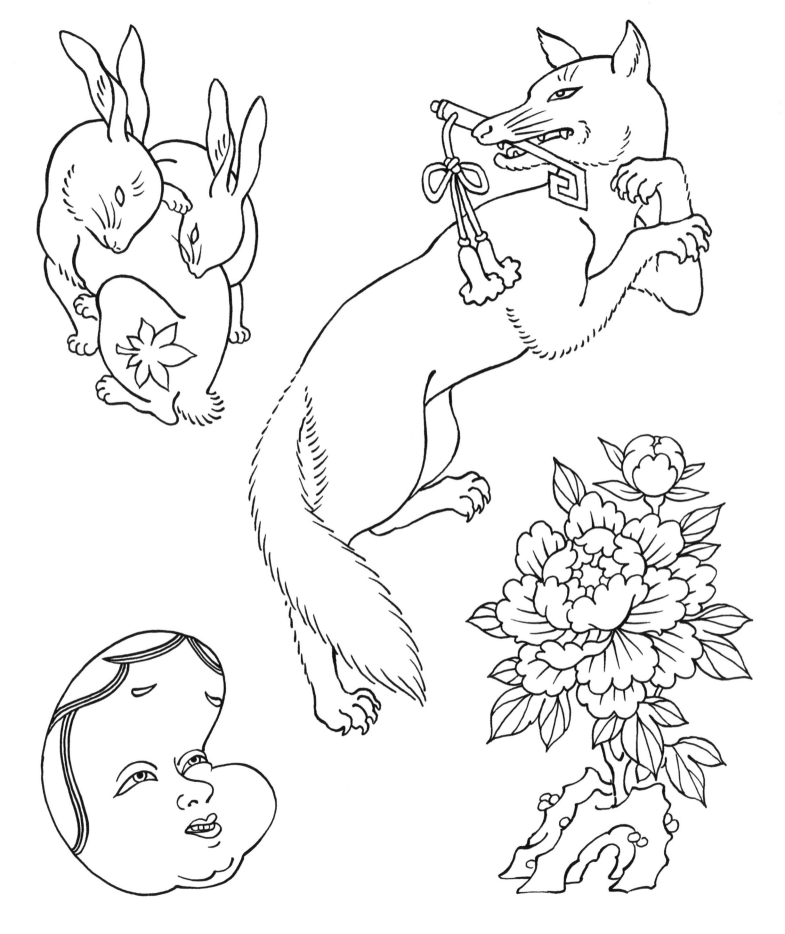

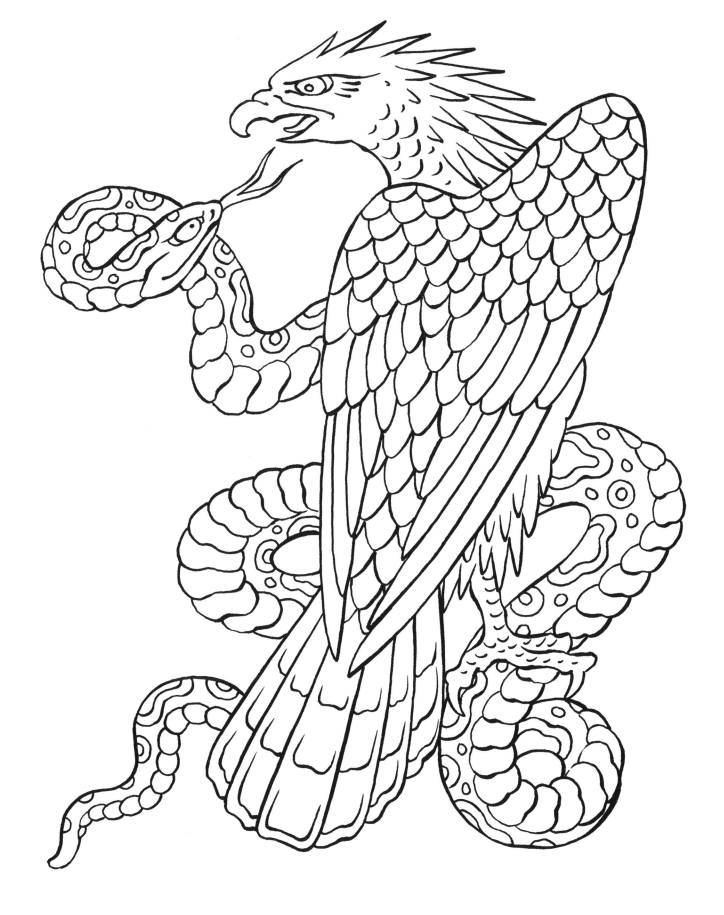

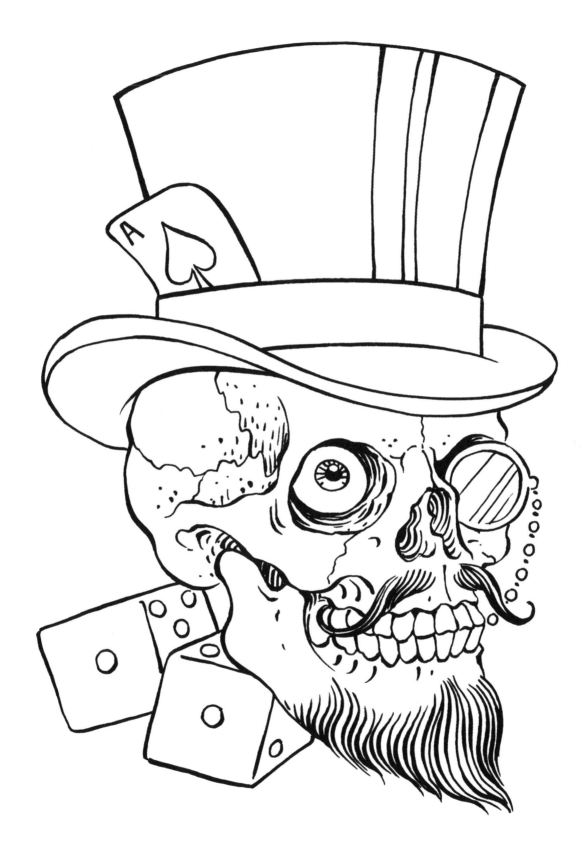

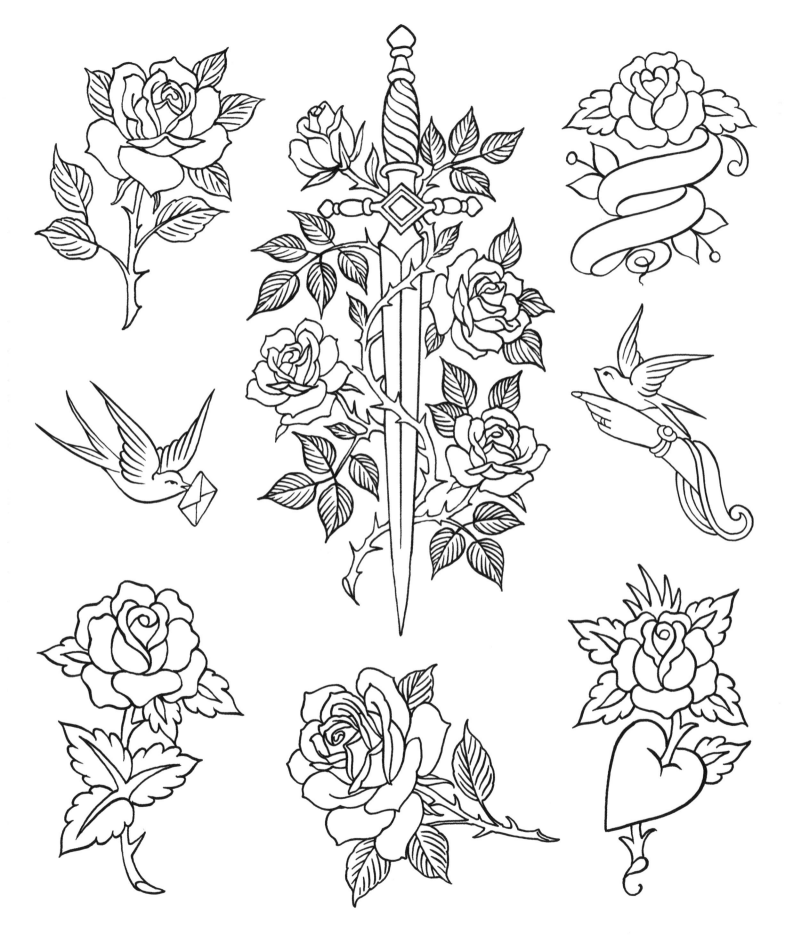

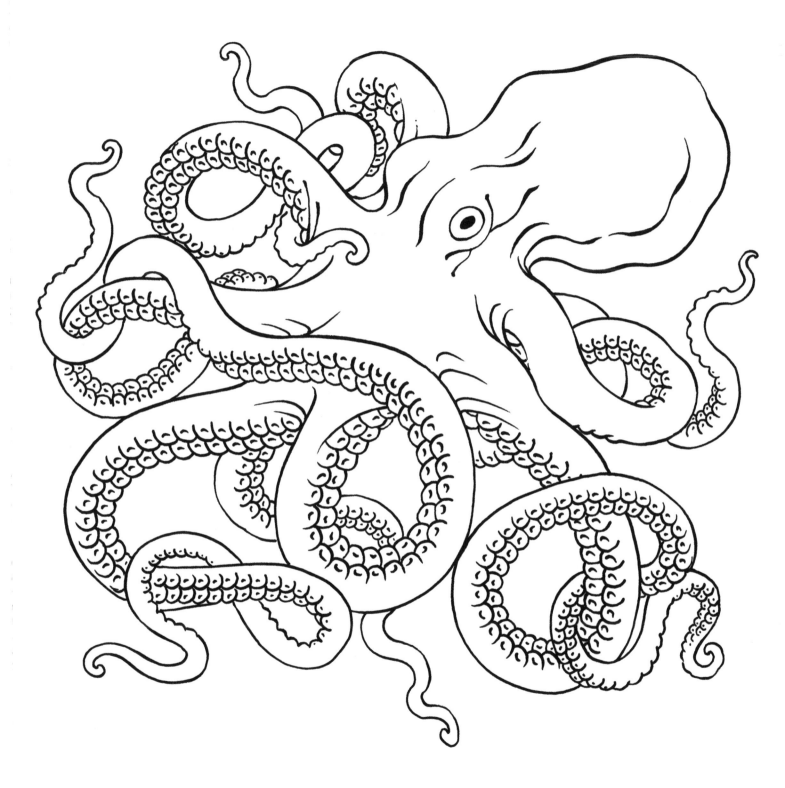

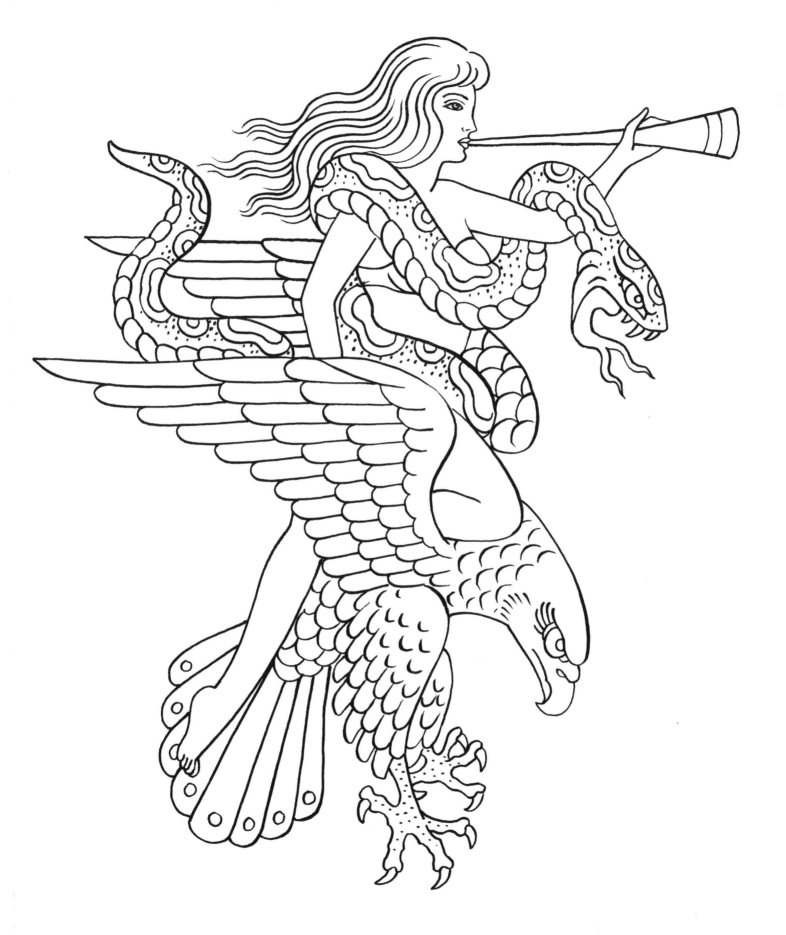

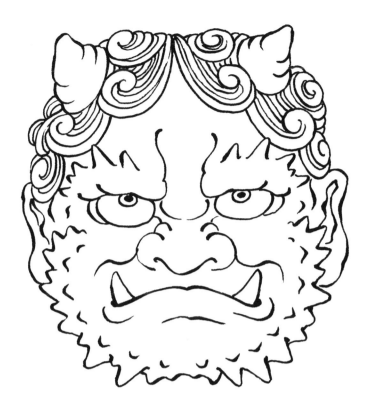

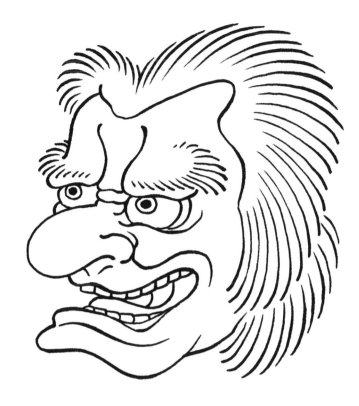

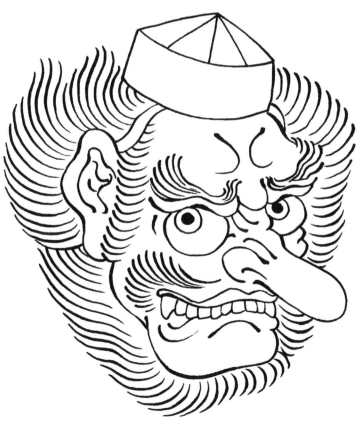

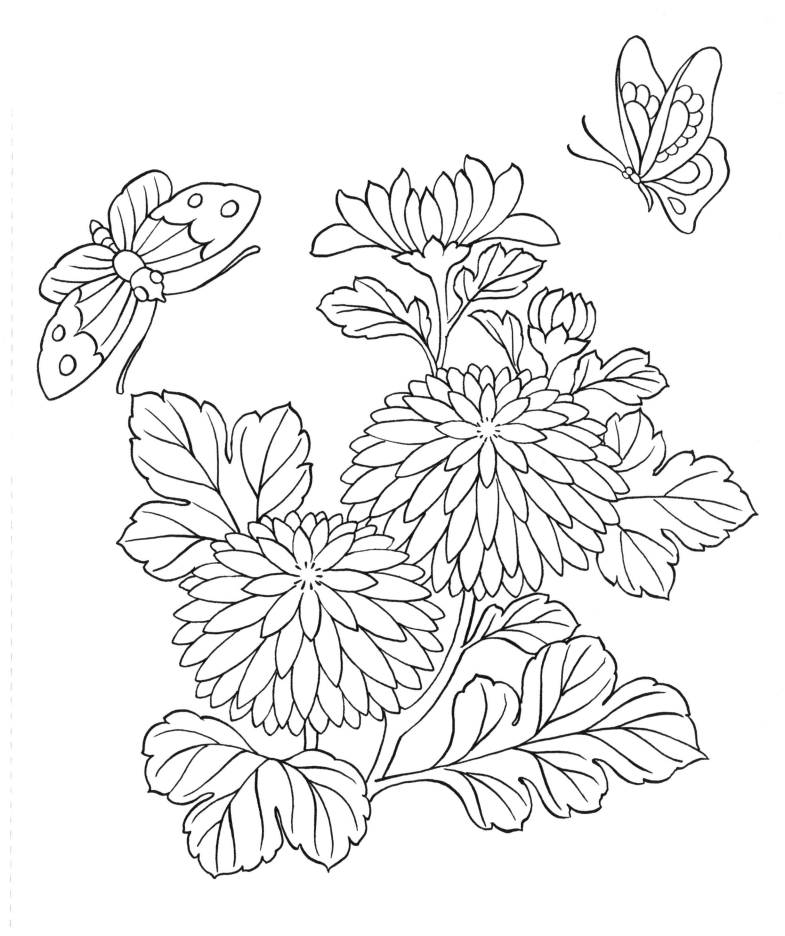

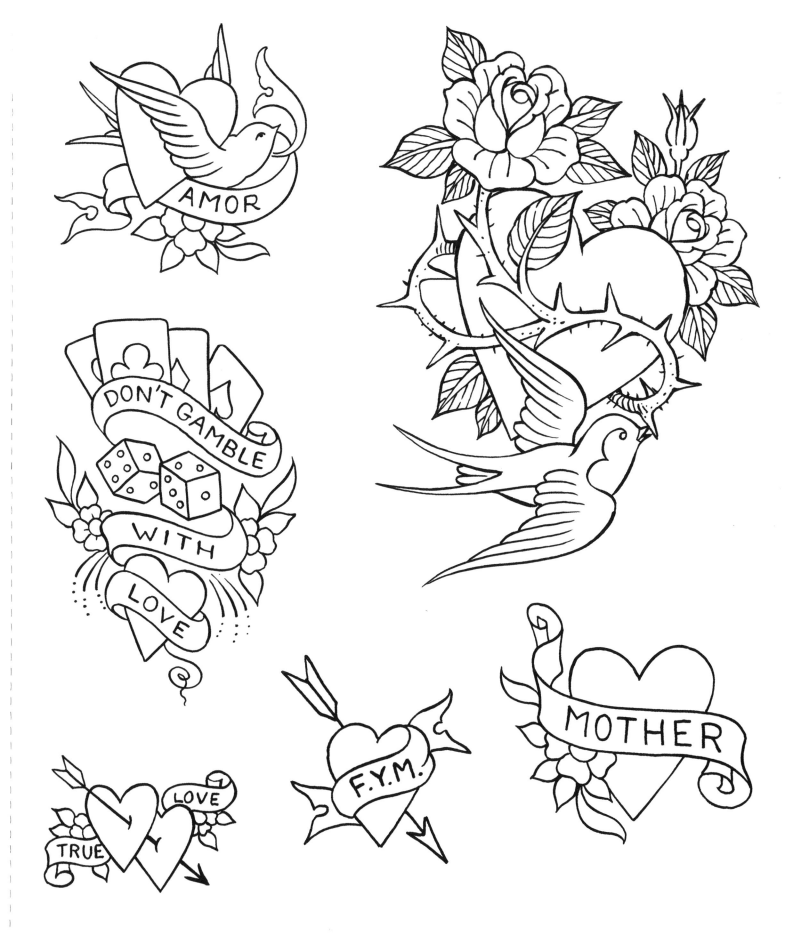

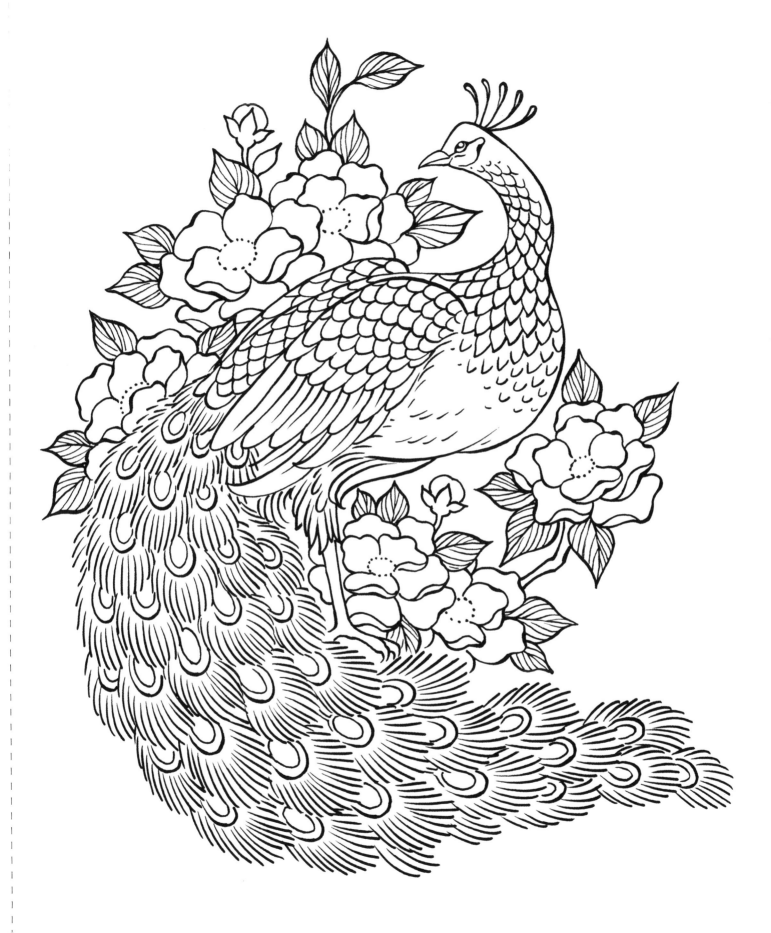

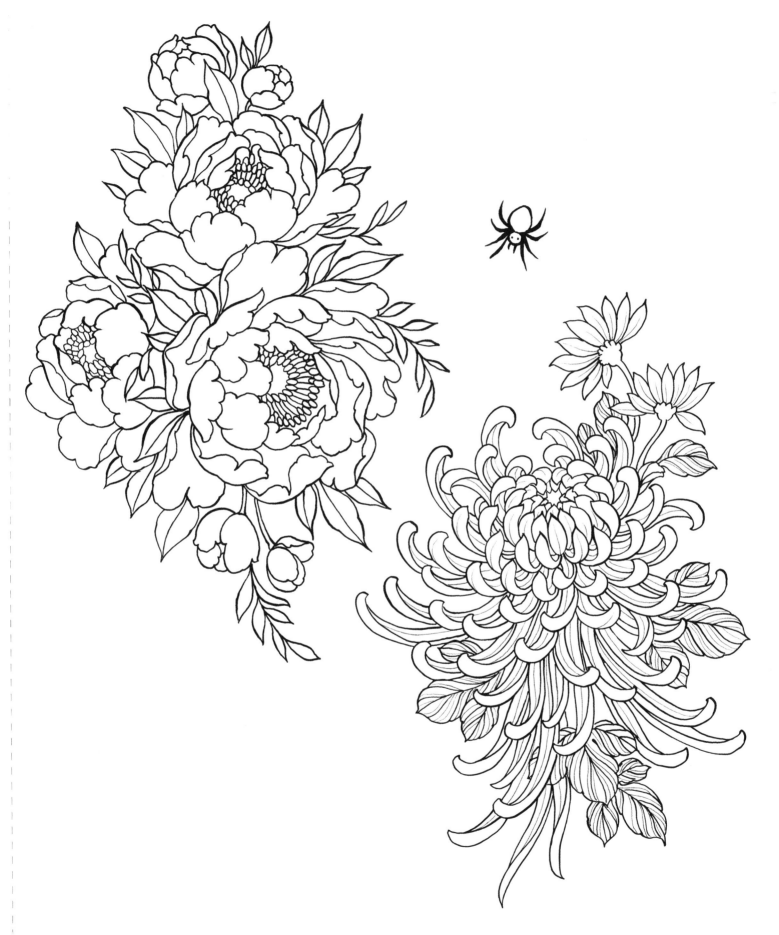

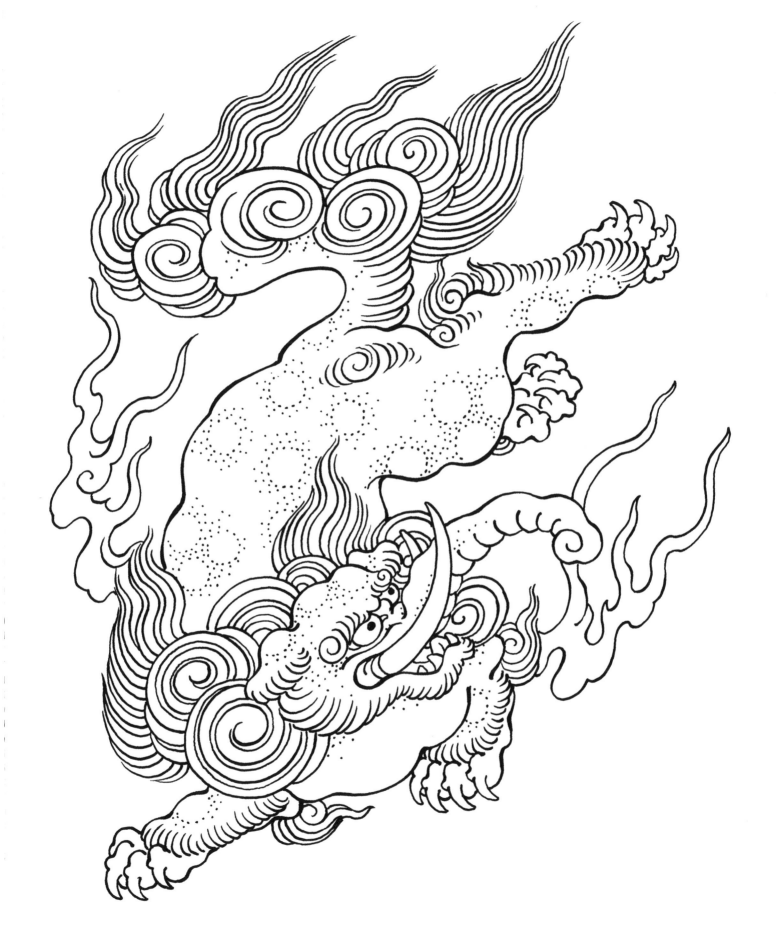

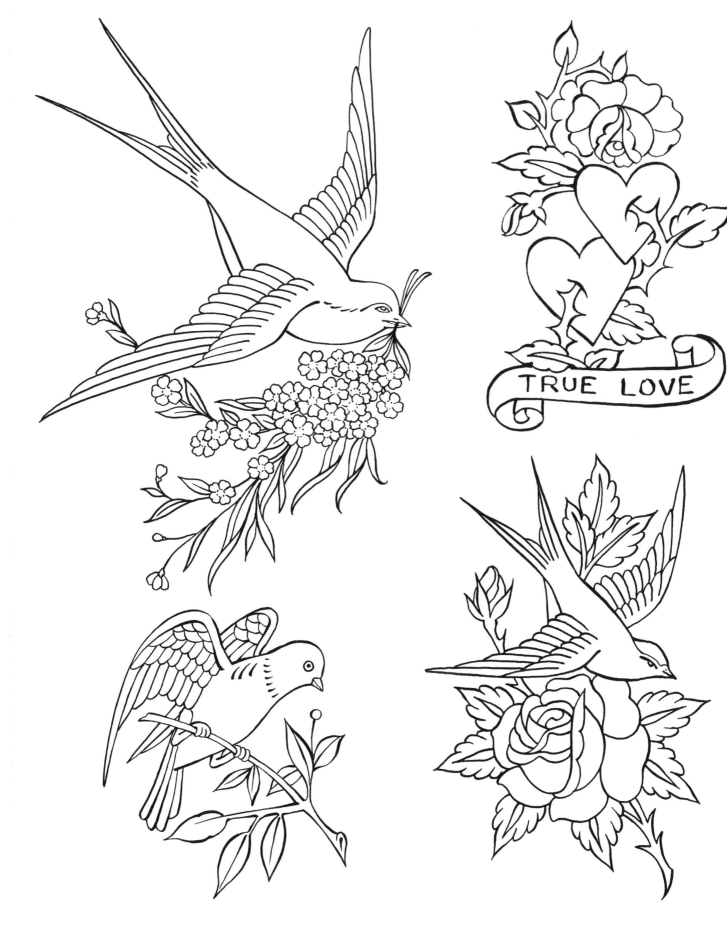

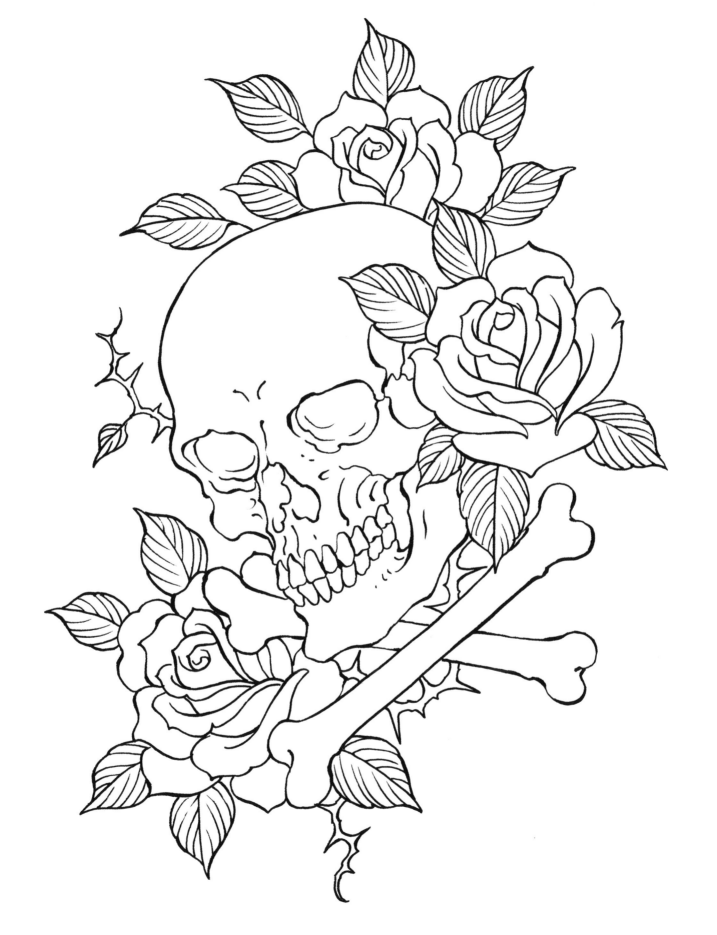

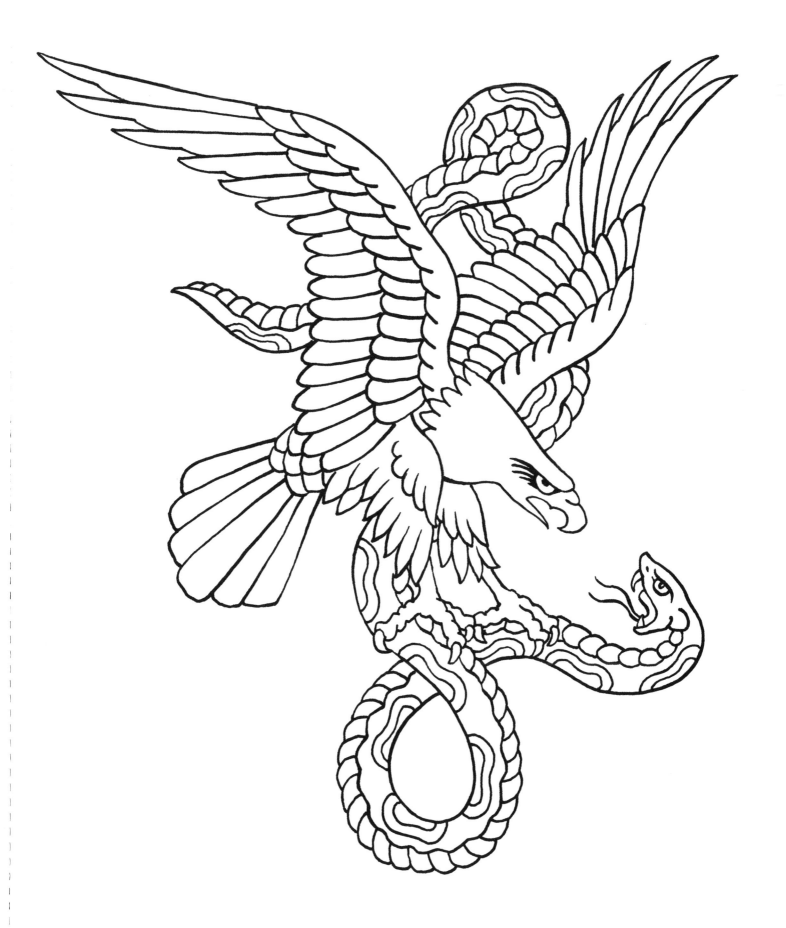

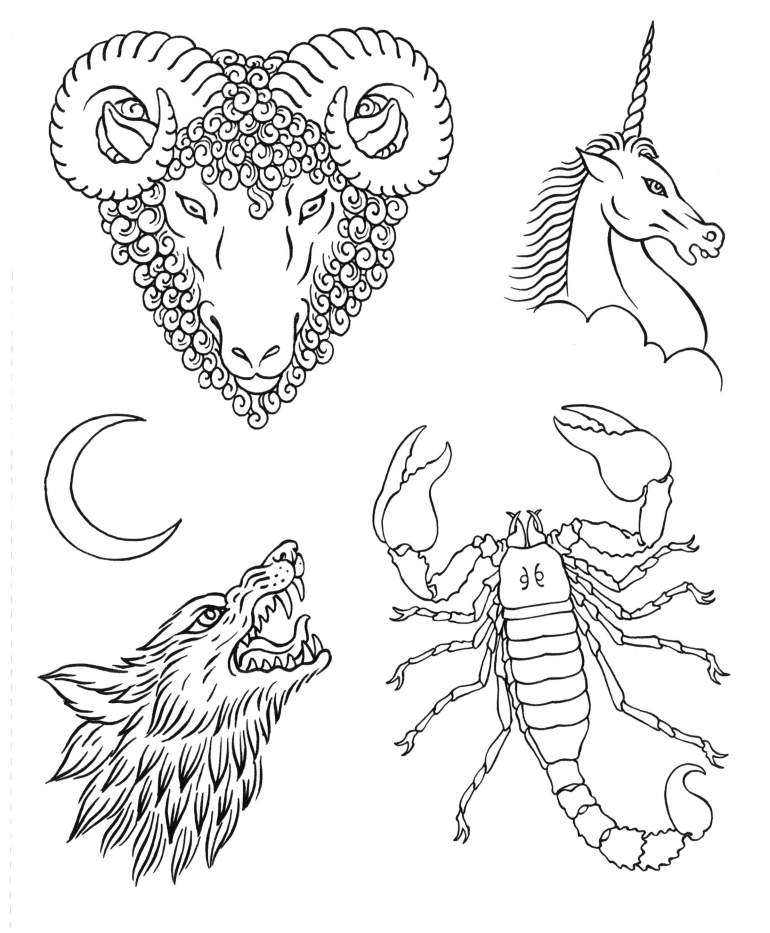

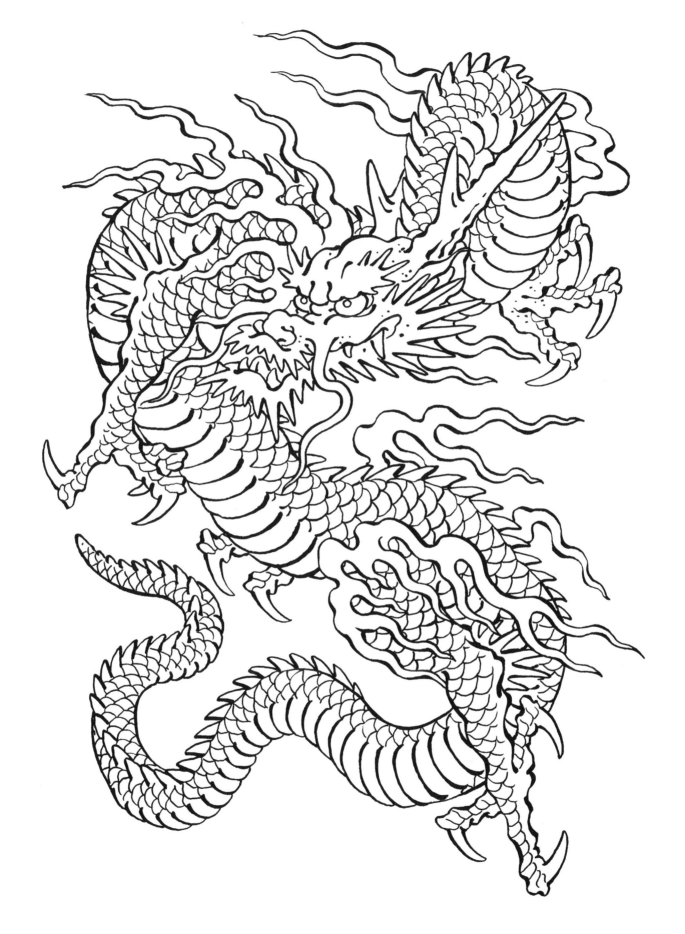

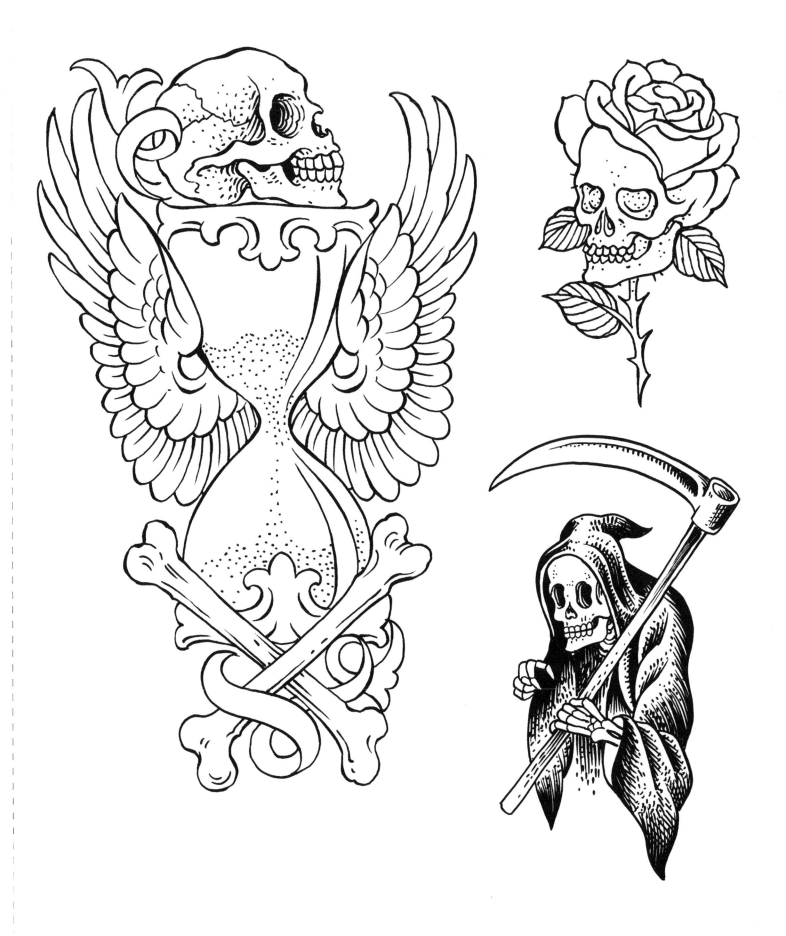

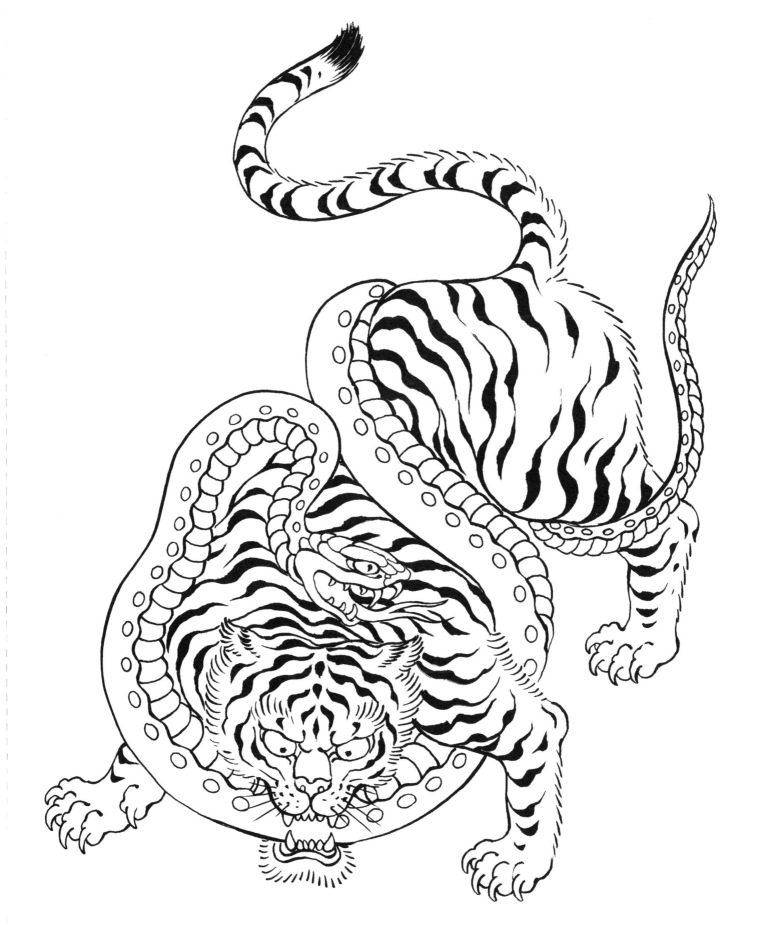

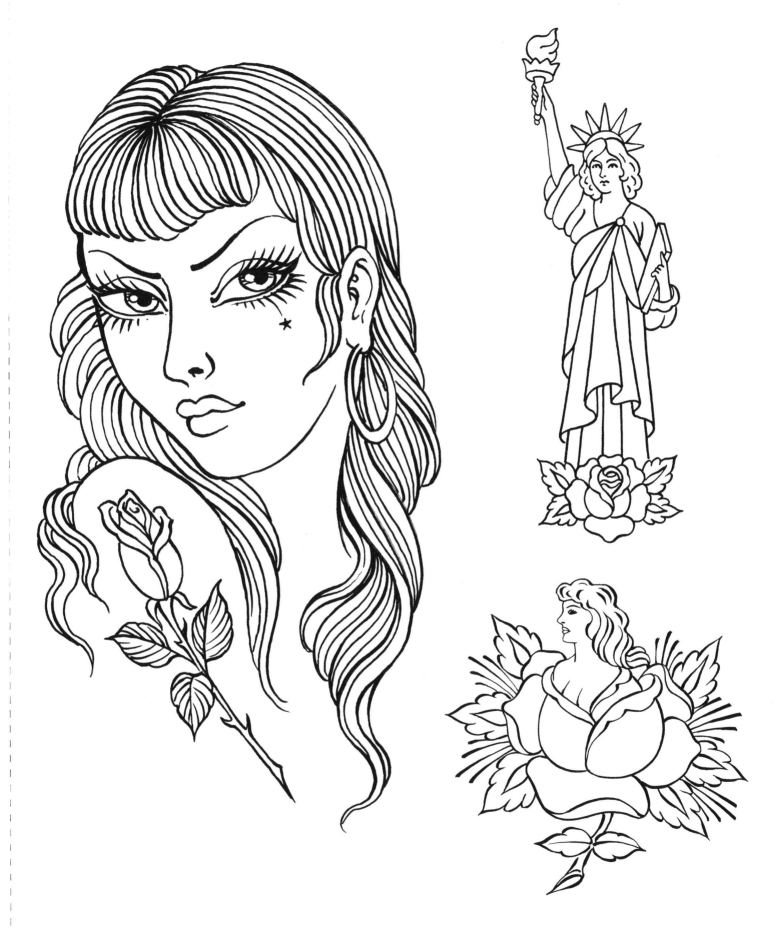

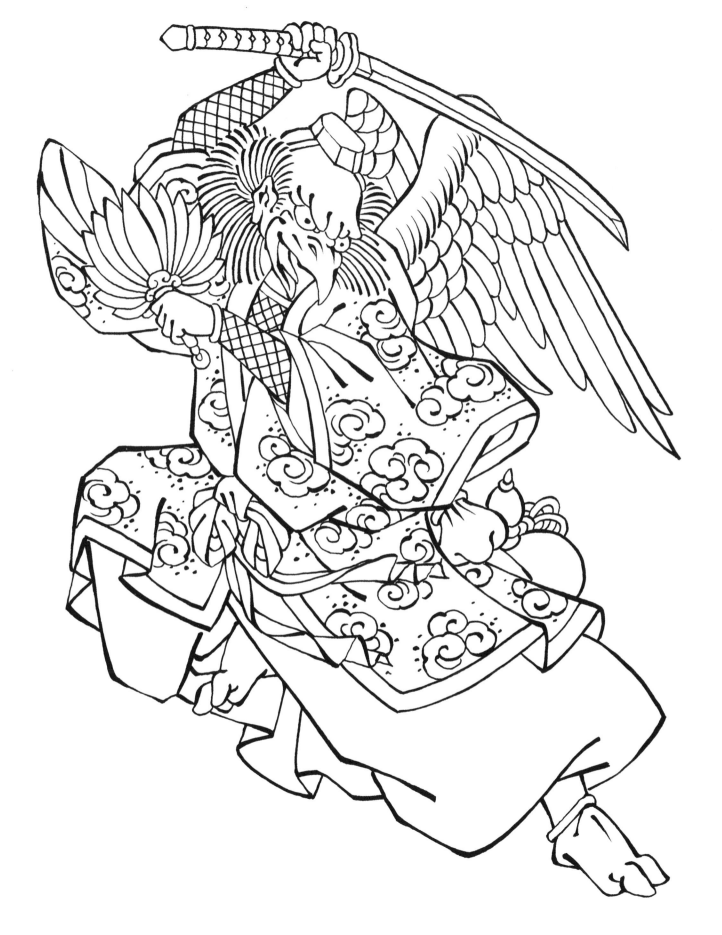